TM & © 2023 Legendary. All Rights Reserved (2023)

INSIGHTS

INSIGHTEDITIONS.COM

MANUFACTURED IN CHINA 10 9 8 7 6 5 4 3 2 1